Directions
In Art

Digital Media

Beryl Graham

www.heinemann.co.uk/library

Visit our website to find out more information about Heinemann Library books.

To order:

☎ Phone 44 (0) 1865 888066

🖹 Send a fax to 44 (0) 1865 314091

🖥 Visit the Heinemann Bookshop at www.heinemann.co.uk/library to browse our catalogue and order online.

First published in Great Britain by Heinemann Library, Halley Court, Jordan Hill, Oxford OX2 8EJ, part of Harcourt Education. Heinemann is a registered trademark of Harcourt Education Ltd.

Editorial: Lucy Thunder and Helen Cannons
Design: Jo Hinton-Malivoire and AMR
Picture Research: Hannah Taylor and Elaine Willis
Production: Edward Moore

Originated by Ambassador Litho Ltd
Printed and bound in China by South China Printing Company

ISBN 0 431 17646 9 (hardback)
07 06 05 04 03
10 9 8 7 6 5 4 3 2 1

ISBN 0 431 17656 6 (paperback)
08 07 06 05 04
10 9 8 7 6 5 4 3 2 1

British Library Cataloguing in Publication Data
Graham, Beryl
Digital Media. – (Directions in art)
700
A full catalogue record for this book is available from the British Library.

Acknowledgements

The Publishers would like to thank the following for permission to reproduce photographs: AKG/DACS 2003 p. **23**; *Artifice and Illusion: The Art and Writing of Samuel Van Hoogstraten*, Celeste Brusati p. **30**; Natalie Bookchin pp. **9, 11**; p. **30**; Diller +Scofidio p. **6**; Jenny Holzer/ARS, NY and DACS, London 2003 pp. **16, 17, 18**; Roshini Kempadoo p. **21**; KIT/Jen Southern pp. **25, 26**; Rafael Lozano-Hemmer/photo Arie Kievet p. **28**, /photo Martin Vargas p. **31**; Mongrel Ltd pp. **12, 14**; Mark Napier/napier@potatoland.org pp. **33, 34**; Jane Prophet pp. **36, 37**; Kate Rich pp. **38, 41**, /Sneha Solanki p. **40**; Paul Sermon pp. **42, 44**; Jen Southern/photo Jonty Wilde p. **27**; Jon Thomson & Alison Craighead p. **5**; Bill Viola pp. **48, 49**, /Deustche Guggenheim, Berlin/Kira Perov p. **46**; Walker Art Center, February 2000, Physical portal for virtual portal, Art Entertainment Network (http://aen.walkerat.org), design by Antenna Design. Used with permision p. **7**.

Cover photograph of a screenshot from *Shredder* (1998), reproduced with permission of Mark Napier (napier@tatoland.org).

The publishers would like to thank Richard Stemp, Gallery Educator at the Tate, London, for his assistance in the preparation of this book

CONTENTS

Any words appearing in the text in bold, **like this**, are explained in the Glossary.

DIRECTIONS IN DIGITAL MEDIA

'**Digital** media' covers a wide range of media that use computer code: communication media such as the **Internet** or mobile phones; digital versions of photography, video or sound; **multimedia** appearing on computers; and varied forms such as **virtual reality** (VR), **Tamagotchi** games, or computer-controlled **robotics**. Although some of this technology is now available in ordinary shops, some is still only available to experts. At different times, people have called this range of media 'new media', 'digital art', 'computer art', 'electronic art' or 'art and technology'. The nature of digital media art is still very changeable and open for debate.

Art and new technology

Since ancient times, artists have used new technologies as they became available, enabling them to extend their creative range. Over time, new processes offered new pigments for painting, and new tools meant artists could develop techniques in stone carving and bronze-working. In the 20th century, artists such as Nam June Paik (b. 1932) used 'new' media technologies like video cameras as soon as they became available. Paik also worked with technicians to help develop new tools for manipulating images, including the first video synthesizer. More recently, artists such as Graham Harwood (see pages 12–15) and Natalie Bookchin (see pages 8–11) have worked with **computer programmers** to help develop **software** tools to manipulate the new digital media. The media used by artists today now ranges from paint to computer code.

> *The Egyptian pyramids are the first example of a combination of high art and high tech, because they used many of the cutting edge technologies of the time. Their culture was very well developed. ...* NAM JUNE PAIK, VIDEO ARTIST.

The artists in this book have been influenced by the new technology, and also by many older forms of art such as photography, or **Conceptual Art** which used words, games and the postal system as part of art making. Below are some examples of the special features offered by digital media, which are not offered in the same way by other media.

Realism, faking and copying

Painting, sculpture, and other art forms have at times tried to be as 'realistic' as possible. Some artists have tried to fake or recreate 'reality'. Victorian photographers used **photomontage** to fake images of 'fairies' at the bottom of the garden. Since these early attempts, improved technology now means that very realistic images of dinosaurs can be made using computer **animation**. One special feature of digital media is the ease with which images and sounds can be copied, **sampled**, faked, put together and manipulated, using software on computers.

Graham Harwood and Roshini Kempadoo (see pages 20–23) use this manipulation of images to make points about history, identity, crime or other issues. Jane Prophet (see pages 36–37), in a different way, uses 'realistic' **simulations** of artificial ecosystems to explore the differences between nature and technology.

Communication

Digital communication media, such as mobile phones, email, digital broadcast videophones and the Internet have all been used for artwork. Paul Sermon's sofas in different rooms, where the audience interacts with each other via a live video link, is an example of this (see pages 42–45). Kate Rich's use of the Internet for radio broadcasts, is another way in which artists can use available technology to show their own work, rather than relying on galleries, museums or mainstream broadcasting (see pages 38–41).

In some ways digital media have made international communication (and international art projects) easier, but there are still large parts of the world that do not have access to such expensive technology.

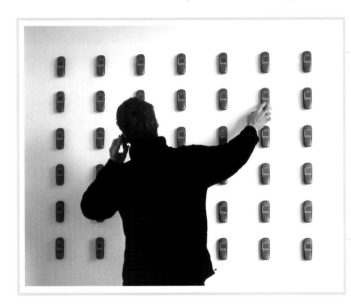

A gallery visitor interacts with Telephony *by Jon Thomson and Alison Craighead. This installation uses music, mobile phones and a lie detector.*

'Choice' and control

Some kinds of digital media will react if the user clicks on a screen, and these reactions can involve complicated choices. The viewing experience is very different to looking at a painting, because a painting does not physically react to audience input. Artists like Elizabeth Diller and Ricardo Scofidio (working as Diller + Scofidio), however, are very critical of the 'hype' about digital media, and they question how much 'choice' the audience really gets.

Diller + Scofidio

Diller + Scofidio are two New York artists who made an artwork where the audience pushed buttons to choose the class and gender of two 'characters' to appear at a 'dinner table'. The characters' hands and voices play out a short, witty mystery story. The characters can be replaced at any time in the story, and the food, clothes and voices change, but the characters are trapped in a repeating story from which they cannot escape. Likewise, with simple forms of interaction, the audience can make simple choices, but they are still under the control of the artist, and the limits of the computer program.

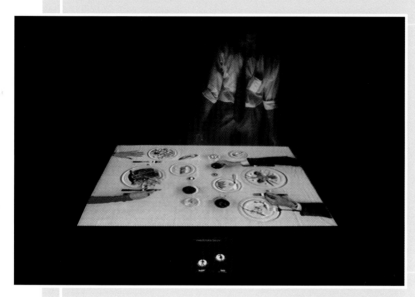

Diller + Scofidio's 1995 artwork Indigestion. *Users can choose the dinner guests using a touch screen, and computers control the **video projection** on to the table top.*

Interaction or participation?

Interaction means acting upon one another, and although it is a special feature of computer programs, there are also other, older art forms where physical interaction can take place between the artwork and the audience. Conceptual Art, **Community Art** or pantomimes, for example, can involve interactions where the audience may be asked to have creative input to the artwork, such as writing on the walls of an art gallery in response to questions by an artist.

Digital media can offer interaction that ranges from the simple pushing of a button, to **installations** like Rafael Lozano-Hemmer's *Body Movies* (see pages 28–31), where the audience can really participate by making shadows with their bodies. Here the artist is handing over a lot of control to the audience. Similarly, with Jane Prophet's *TechnoSphere*, after the artist has designed the 'world', it is left to 'evolve' over time, through audience interaction.

Immersion

By wearing virtual reality headsets, users can have the impression of being 'immersed' in images and sound, because they can see computer graphics in three dimensions. Jenny Holzer has used virtual reality to make 'artificial worlds' for artworks (see pages 16–19), and artists such as Natalie Bookchin have used the structures of game playing and storytelling to get the audience involved with serious issues. However, it has been debated that immersion (like interaction) is not unique to digital media. The 'actual reality' of installation art, or architecture, also offers immersion, with the added senses of touch and smell. People playing computer games often get very 'immersed', even if they are not surrounded by images.

Artists and galleries

Artists using digital media may work in very different ways to solitary painters. Often, they work in partnership with computer programmers, or even in large teams of people in order to organize big public events. When it comes to art galleries, how do you 'exhibit' a web site? Today, some art museums such as the Walker Art Center in the USA have special 'galleries' that only exist on the web for Internet Art, and some show them in the museum building, too.

Digital media are developing fast, and digital art is changing in an exciting way. The artists in this book have been chosen because they have strong ideas and artwork, and because they use a wide range of different digital media, from cheap and accessible, to high-tech and expensive. Digital media offer not only new ways of making art, but new ways of looking at art.

A 'portal' for looking at Internet Art in a gallery, from the exhibition Let's Entertain, Walker Art Center, USA.

NATALIE BOOKCHIN

Natalie Bookchin is an artist who has worked individually, and as part of a team, to make artworks based on computer games. She was born in the USA in 1966, and studied Fine Art at the School of the Art Institute of Chicago. She now lives in Los Angeles and teaches at California Institute of the Arts. Her early artwork included photography and textiles, and she was an early user of the **Internet** for educational and **activist** purposes in the 1980s and 1990s, long before commercial companies used it to sell products. Bookchin then became interested in computer games. These are often thought of as being just for children, but artists' games can have a serious message.

Computer games

Computer games made by artists are deliberately different from commercial computer games: commercial games are often very violent, and artists' games tend to challenge or make fun of that violence. Commercial games are often made by, and for, young males, but Bookchin works with both women and men. Commercial '**simulation**' games such as *The Sims* are often about very conventional family structures, or about very American kinds of business or city planning (such as *Simcity*), but Bookchin has worked with community groups in different parts of the world, and challenges the usual themes in commercial games by showing other ways of life.

Metapet

Metapet (2002) is a simulation computer game that can be played on the Internet. It is like a **Tamagotchi** game where you have to keep a computer 'pet' alive and happy, but in this case the pet is a worker in an American-style industry.

The game-player is the 'boss' of the pet, and has to make choices which affect the worker, such as how much to pay, what kind of company perks to offer, or what kind of punishment to give. The player can also choose 'visual standards' to make the pet change appearance. Visual standards refers to the rules that some companies have about the appearance of their employees, for example some workers are not allowed to have beards, tattoos or to be overweight. The pet will react in certain ways to the choices that have been made, and may eventually leave its job or get its revenge! The game criticizes some kinds of work culture. It also makes fun of the biotechnology industry (technology applied to change living things) and genetic engineering (changing and deliberately rearranging genes), because the artist has drawn the 'pet' as part human and part animal.

The publicity for the game pretends that the pet has been created by genetic engineering, and has been made with '... an obedience gene from a trained dog, which has been designed to create a new class of worker that is much more loyal and productive...' As well as the main pet game, there are also related 'mini-games' within *Metapet*, by guest artists such as Jeff Knowlton, who made *Field of Bees* – a mini-game about genetically modified corn.

By using fantasy, humour, and an **interactive** game-playing structure to engage the user, *Metapet* aims to make people think about everyday issues of business and genetics. The choices of the boss are saved on the web site, so that users can return to visit their pet and see how it is doing over a long period of time.

An image from a screen of the Metapet *game, showing the pet in an office cubicle. The player can choose the office and furniture, as well as the appearance of the 'pet'.*

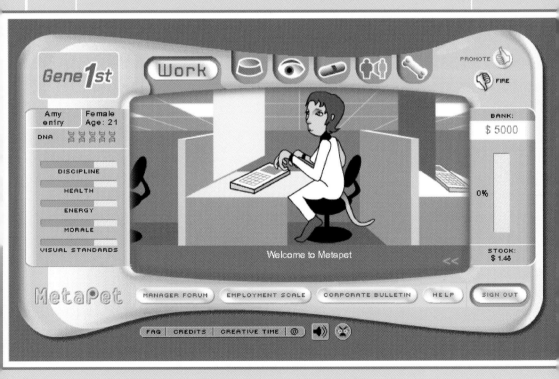

... computer game development requires money, time, and resources that many artists don't have access to. On top of this, games require teams of artists, programmers and designers...
NATALIE BOOKCHIN

Techniques

To make this artwork, Bookchin worked with a group of around six people called 'ActionTank', a group that she founded in 2000. The team includes **computer programmers** and graphic designers. The **software** used included Flash® and Shockwave®, which enable the user to move images around interactively on a **web browser**.

In a group project, the artist usually decides what the game will be about, and how the interaction should work, the designers help with how it looks, and the programmers make it work. With Internet artwork, it is also important to make sure that people can actually find the artwork amongst all the other material on the Web. *Metapet*, for example, was publicised and 'exhibited' on web sites by arts organizations in New York and Barcelona.

Games on the Internet tend to be much slower and simpler than video games, because the Internet is rather slow at transmitting images and other information. Artist's games may also have different aesthetics, meaning that they look very different to commercial computer games. For example, *Metapet* imitates the 'clean' style of genetics industries, rather than the dark 'gothic' style of some violent computer games which are set in dingy, dungeon-like places.

Influences

Bookchin has pointed out that the group of artists known as the **Surrealists** used games of chance to help creativity. These include the '*Exquisite Corpse*' game where one person draws a head, folds the paper over, and the next person draws a body. She also draws inspiration from other artists who have treated games seriously, including Marcel Duchamp (1887–1968), and the Fluxus Group (1960–1970s), who were a group of **conceptual artists**, using 'actions' and game-like interactions between audience members, rather than simply making objects.

Bookchin has also examined the work of the young artists Jon Thomson (b. 1969) and Alison Craighead (b. 1971) who have worked with Internet-based computer games such as *Trigger Happy*, a game that involves shooting down the words of a famous author who writes about culture. She is influenced as well by computer game companies, such as Eric Zimmerman's GameLab.

Communities and stories

In 2001 Bookchin worked in Marseilles, France, with a community group called *La Compagnie* in a poor part of town where mostly North African French people lived. She worked with children and young people to make simple computer games based on her own software. The children put in their own characters and scenes, from their imaginations and lives.

Another of Bookchin's art games is called *The Intruder* (1999). It looks like simple computer games such as *Space Invaders* and *Pong*, but is based on the book *The Intruder* by Jorges Luis Borges, a South American writer, and tells a story through a series of games.

In Turdera, where they lived

This image, from a screen of The Intruder *game,* shows the Space Invaders-*style game.*

GRAHAM HARWOOD

Graham Harwood has worked with **CD-ROM** and **Internet** Art. He often works under the name of 'Harwood', and sometimes with the group 'Mongrel' that he founded with Matsuko Yokokoji, Richard Pierre-Davis and Mervin Jarman. He was born in 1960 in Brighton, UK.

Harwood's past artwork includes print, such as **photomontage**, graphic novels (comics) and home-made magazines, as well as **digital** media. His artwork is concerned with issues that affect society, including crime, mental health and social class. He lives in London and has shown his artwork in many different countries.

Uncomfortable Proximity

Taken from the Uncomfortable Proximity *(2000) web site, this image shows a photomontage with parts from a William Hogarth painting and parts of photographs of Harwood's mother.*

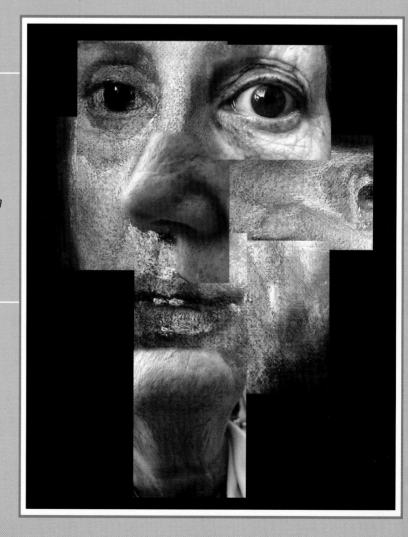

Uncomfortable Proximity is a web site that was created to exist alongside the official Tate Britain web site. Harwood copied the style and colour of the Tate web site then replaced the words and images with his own. This artwork was **commissioned** by the Tate Britain. It was the first time that the Tate had chosen Internet Art for their web site.

Harwood took digital photographs of famous paintings that were stored in the permanent collection of Tate Britain. He then used digital photomontage to put together parts of these paintings with photographs of the skin and hair of his family and friends, and photographs of mud and debris from the River Thames outside the gallery. He contrasted the smooth paint of flattering portraits with close-ups of the actual skin of real people of different ages and races, and he put the texture of paint next to the texture of dirt and mud.

Sampling

Harwood's own photomontages are displayed in the 'collections' part of the 'fake' web site. *Uncomfortable Proximity* uses the **sampling** or copying aspect of digital media. Just as parts of a pop song can be digitally 'sampled', and parts of it used in a new song, parts of web sites and images can also easily be copied and re-used.

Harwood wanted there to be some confusion between his Internet artwork web site and the official Tate web site, because he felt that some art museum sites were more about selling items from the museum shop than about showing Internet Art.

Revealing the true stories

Harwood wanted to reveal the 'dirt' and the real stories and people behind the 'clean' publicity for a high-status art gallery. For example, he re-wrote the 'history' pages of the Tate web site. This revealed the real history that from 1776 there were once prison ships moored on the River Thames near the gallery site. The hard labour punishment for the prisoners was dredging the river (digging up the mud) so that the 'new technology' of bigger ships could sail along it and use it for business.

New technology is sometimes thought of as being 'clean', but Harwood asks us to question that:

> *For a long time we have assigned to machines our dirty laundry whilst maintaining the image of their enameled white veneers.*
> GRAHAM HARWOOD

Shared themes

Harwood chose many of William Hogarth's (1697–1764) paintings from the Tate collection to use in his **montages**. The two artists share some interesting themes. Hogarth's series of **engravings**, such as *The Rake's Progress,* were very popular, and told stories from the underworld of society. The engravings were also mass-produced, and Hogarth campaigned to bring in the first law that protected the copyright of engravings, so that other people could not copy or 'sample' them.

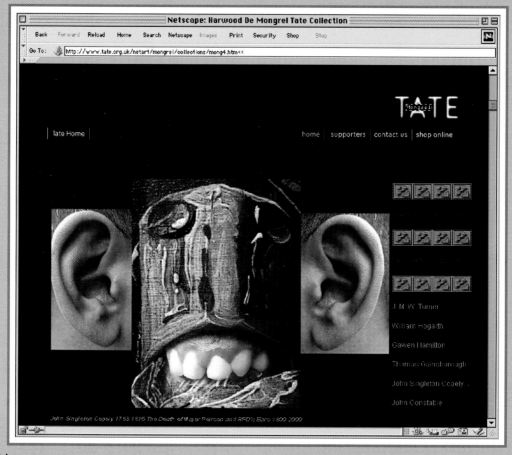

Programming

Harwood designs and programmes his own web sites, including *Uncomfortable Proximity*. He sometimes works in collaboration with others, and also trains other people to programme. He manipulates and montages images using whatever **software** is available, and tends to use inexpensive equipment.

Making software

Mongrel (the group that Graham Harwood works with) has been involved in making free software. *Linker* is a software for making **interactive multimedia**. Images, video and sound can be put together quickly and cheaply. This method was developed for the art workshops that Mongrel does with community groups. They do this in order to work with people who may not be experts, but want to express themselves through this kind of art.

Harwood has also worked with Sarai, a media workshop in New Delhi, India, which makes software to give away. In this way, people don't have to pay for very expensive commercial software. The artists then have a wider range of software 'tools' to experiment with, because these tools are made by artists themselves.

CD-ROM artwork

Harwood also produces artwork on CD-ROM. *Rehearsal of Memory* (1995) was an interactive CD-ROM produced by Harwood with people in a high security mental hospital. People tend to be very afraid of such places, but many of the men that Harwood worked with were there because they were a danger to themselves rather than to other people. Cameras were not allowed in the hospital, so the artist and the patients pressed their bodies against a **scanner**, and then put those images together to make a grid of body shapes from a mixture of people. Users of the CD-ROM are able to click on parts of the body on the computer screen to move around. If they clicked on certain marks or scars on the body, then they could hear a story associated with the life experience of a patient – often sad stories from their childhood. The viewer is very close to the 'bodies' of the men, and the interaction of choosing what scar to click on is very different to the fast and careless clicking of many interactive CD-ROMs. The artwork had the serious intent of getting people close to problems that many people would rather not think about.

JENNY HOLZER

Jenny Holzer is an American artist, born in Ohio, USA, in 1950. She is most famous for her artworks where words are very important. Since 1977 her *Truisms* (which are phrases, such as 'Abuse of Power Comes as No Surprise'), have appeared on bus tickets, posters, electronic signboards, the **Internet**, and been projected on to the sides of buildings. She has exhibited at famous museums and art festivals, such as the Venice Biennale.

Working with words

Untitled (1989) used a very long electronic-display signboard, on which long streams of text in different colours moved. The words included such phrases as 'Protect me from what I want', and other sayings from her *Truisms* series of artworks. Holzer's phrases are very carefully written to make the viewer ask questions about what the words mean, for example, why do we want things that are bad for us? Electronic-display signboards are more usually used for news, information or advertising, so having strange phrases appearing on them tends to surprise the viewer. This artwork appeared in an art museum, but Holzer also likes to reach different audiences by showing her artwork in public places such as buses and outdoor billboards.

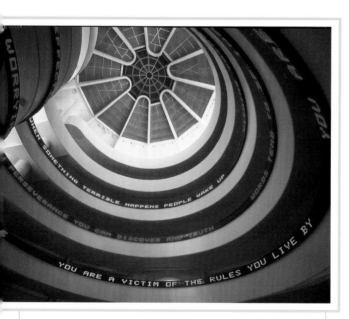

Untitled (Selections from Truisms, Inflammatory Essays, The Living Series, The Survival Series, Under a Rock, Laments, and Child Text) *(1989)*, *in the Guggenheim Museum in New York. The L.E.D. electronic-display signboard spiraled up four floors of the museum's huge central atrium.*

Virtual reality

Holzer is one of the few artists to have worked with **virtual reality** (VR), which uses digital images with a 3-D headset to give the visual and audio impression of moving through a three-dimensional space. Some arcade games use VR for adventure experiences where the user seems to be flying in the air or fighting through buildings or landscapes. Usually, these images attempt to be realistic, but Holzer's work with VR creates a landscape of a strange and symbolic kind.

World II

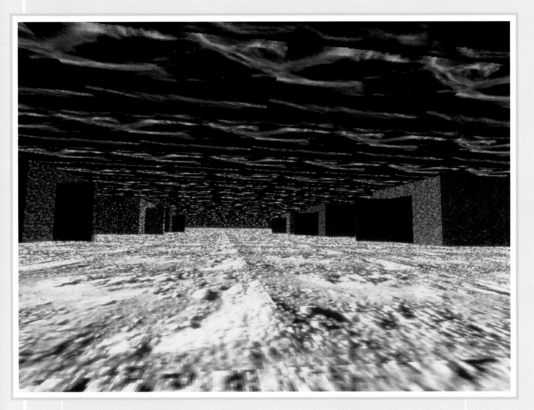

This digital image of World II *(1993) shows the huts and the changing landscape. If seen through the VR headset, the images would appear to be three-dimensional.*

In the artwork *World II* (1993), the user can 'move' through a strange, desert-like **digital** landscape. There are a variety of small block huts grouped on the land, and if the user goes inside, the hut looks abandoned, but voices can be heard. Some of them speak of ordinary things like birds or light, but in a disturbing tone of voice. Whenever the user comes out of a hut, the landscape and sky have changed. At first the voices are mysterious, but eventually the user realizes that all the voices are reading the words of people who were involved in the Bosnian war in the early 1990s, as witnesses, victims or perpetrators of violence. The empty houses are computer models and not actual buildings, but could represent any war zone in the world, not just Bosnia in the former Yugoslavia. Landscapes created with computer graphics are seldom completely realistic, so the artist uses the strangeness of the unreal landscape to build up a sense of fear over time.

Immersion

Virtual reality (VR) is 'immersive', which means that the point of view of the user is 'surrounded' by images and sound, and it can have a powerful effect on the senses. Some people say that making VR is like 'making a world'. The user can choose where to move within an artificial space, and objects may respond to the position of the user, but VR is not necessarily very **interactive**, because the user may not choose what happens. Only one person can wear a 3-D headset at a time, so VR is usually a very individual experience.

World I *(1993) was a simpler, earlier VR artwork. It was a cavernous landscape with floating 'souls' that are represented as cubes with **animated** faces on them. If the user made contact with one of the souls, then it spoke a Holzer phrase.*

The content of *World II* is very different to the usual VR violent video games, where the user often inflicts violence, but never hears the point of view of the victim, or hears what happens long afterwards. Having VR in an art gallery is still very unusual. It was this combination that interested the artist.

Working with experts

Since 1993, VR has become capable of faster movement and smoother graphics, but is still relatively expensive and high-tech to make. Holzer was sponsored by a major technology company for *World II*, and worked with specialist VR programmers, who worked to her instructions for two weeks. The most important things in Holzer's work are the words and the ideas. She decides the content, and how things should look, and then she often works with technicians to make the technology work.

> *I'm always trying to bring unusual content to a different audience, a non-art-world audience.* JENNY HOLZER

Influences

Holzer has been influenced by debates about the role of art, as well as by other artists. She studied at the Whitney Museum of American Art in the 1970s and is especially interested in debate about art in public places. She has also been inspired by the artist Nancy Spero (b. 1926), who drew images on walls and worked with hieroglyphs (Ancient Egyptian symbols).

Another influential artist who works with text is Barbara Kruger (b. 1945), who made big public artworks such as billboards with the slogan 'We don't need another hero' and 1950s-style pictures. The **Conceptual Art** movement often used words or sounds instead of images.

There are not many artists who have access to VR, but Char Davies (b. 1954) has also worked with a team of technical experts, sound and image designers to make artworks such as *Osmose* (1994–95). Here, the user controls the movement through the space by wearing a vest that responds to leaning and breathing. The user appears to be moving through transparent images of water, earth, air and trees, and the effect is very different from commercial VR games.

ROSHINI KEMPADOO

Roshini Kempadoo is an artist who uses **digital photomontage** and **Internet** sites to make artwork about personal and cultural identity. She was born in the UK in 1959, and has also lived and worked in the Caribbean and Spain. She has worked for Autograph (The Association of Black Photographers), at Format photo library, and studied at the Schomberg Center for Research in Black Culture in New York. She teaches at the University of East London.

Kempadoo's work is influenced by documentary photography, such as Armet Francis's (b. 1945) photographs exploring black identity through picturing everyday life. She is interested both in representation (for example, exploring how black people are represented in newspaper images) and in reality (for example, asking if photographs really tell the truth). Because many historical images of black people were taken by white colonial people (only they could afford cameras), she is also interested in how black people represent themselves with family photographs and documentary photography.

Future Belonging

Future Belonging (2000) consists of a set of large **digital prints** that hang on gallery walls, and an interactive web site that can be used in the gallery or from anywhere with an Internet connection. Both prints and web site use digital photomontage to put together images of real backgrounds, portraits, family photographs and historical documents relating to the histories of people of different races. On the web site, clicking on different parts of these images triggers more pictures and sound. The user can choose from subjects such as 'descent' (which triggers images about family history or genetic history) or 'similitude' (which questions how people are different, and what might be 'normal').

Interactive questionnaires

On the web site, there is also a list of 'profiles' that look like a scientific survey. These are interactive questionnaires that people have answered on the web site, and include such questions as, 'What are the official documents you have with you now or normally carry around with you?' Each person who completes a questionnaire is given a 'profile number', and a photograph that looks like it was taken secretly by a surveillance camera, but does not actually identify them. The 'profiles' reflect the ways in which people are subject to surveillance on the Internet, or by scientists, security or medical officials.

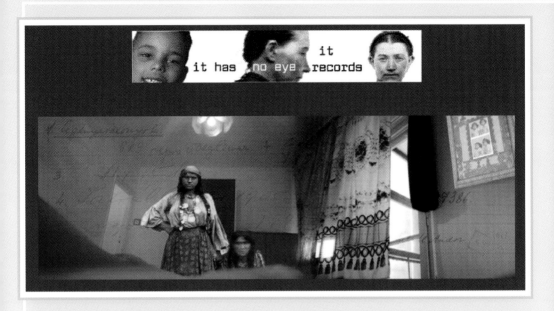

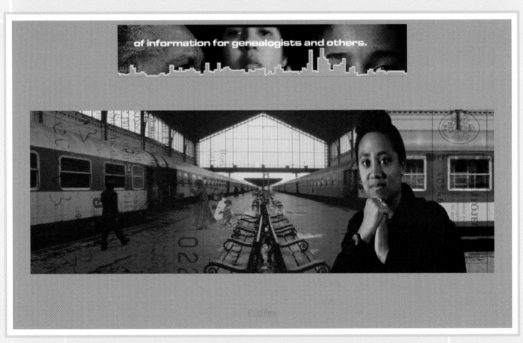

Screen images from the Future Belonging *web site. The* **animated** *smaller images at the top of each screen mimic the advertising 'banners' found on some commercial web sites, but they are designed as part of the artwork.*

Future Belonging questions why people are put into categories because of their
genetic codes. Our race is determined by genetics, but so are other aspects of
our lives. For example, in the USA, people with genetically linked illnesses
might find it difficult to get health insurance.

Working method

For this artwork, Kempadoo started with an idea, and did research into
historical images such as Victorian photographs that classify black people in a
'scientific' way. She then **scanned** photographs, or took photographs with a
digital camera, and used **software** such as Photoshop® to manipulate the digital
images, and to put them carefully together. These images can either be printed
on a digital printer, or viewed on a computer screen. The artwork was made
with a media arts centre in Hungary for the Internet site. Kempadoo worked
with two other people on the sound and music, and the interactive
'profile' parts.

Billboards and family snaps

In 1992, Kempadoo made a series of digital prints called *European Currency
Unfolds*. She scanned in banknotes from EU countries and **montaged** them
with images of people working in the colonies of those countries. These people
contributed to the wealth of European countries, but do not usually appear on
banknotes. One of these images was chosen to be enlarged and put on an
advertising hoarding for the Birmingham Billboard Project in the UK.

Virtual Exiles (2000) was another Internet site artwork. Kempadoo's images
appeared on the web site, but other people were also invited to send in their
own photographs, sound or video recordings about their life experiences at
home or living outside their home country.

Photomontage

Soon after the invention of photography, Victorian photographers, such as Oscar G. Rejlander (1813–75) were putting together images from different negatives. Later, John Heartfield (1891–1968) made images by cutting and pasting photographs to make political comment. He used his artwork to criticize the rise of the Nazis in Germany.

Photomontage takes a lot of care to put together to get the right **composition**, lighting and colour balance. Today, digital image manipulation software, such as Photoshop®, allow this to be done on the computer screen rather than in the darkroom. Pedro Meyer (b. 1935) was one of the first photographers to work with high-quality digital prints, and has also worked with digital photomontage. More recently, the digital media artist Keith Piper (b. 1960) has worked with photomontage in video and **CD-ROM** artworks to explore technology, race and identity.

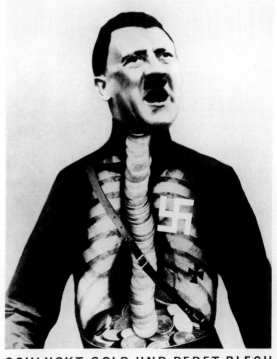

ADOLF – DER ÜBERMENSCH

SCHLUCKT GOLD UND REDET BLECH

John Heartfield's photomontage Adolf the Superman Swallows Gold and Spouts Junk *(1932).*

23

KIT are an international group of young artists, who deliberately choose not to identify their gender, race or location. The artists work in galleries, in public spaces and on the **Internet**. The group also uses the skills of other people such as landscape designers and architects depending on the needs of their projects. Because they work with other people and community groups, they have to be good at helping and communicating. Members of KIT live in the UK, Canada and Australia; they use email and the Internet to communicate with each other, as well as for artwork.

> *... KIT construct, fall apart and reconstruct for each project they do.*
> KIT PUBLICITY MATERIAL

KIT is influenced by the history of the places where the group work, and the particular tools that they use for each project. The chalk markings on the grass of *Kit Homes*, for example, make reference to the huge figures cut from turf to show white chalk underneath, such as the Cerne Abbas giant in Dorset, UK, which was made in the 9th century.

Joyriding in the Land that Time Forgot

Joyriding... (1998) was made for Yorkshire Sculpture Park in the UK, which is set in the grounds of a stately home, and has outdoor sculptures by other artists, such as Henry Moore (1898–1986). KIT exhibited a series of wheeled 'tents', made from canvas that had been printed on a **digital ink jet printer**. The images on the tents are of background landscapes from computer games such as *Jurassic Park*. The tents are scattered across the lawns as if they have veered off the road that winds through the sculpture park. Unlike the large permanent sculptures in the park, this artwork was only displayed for a few months, because the materials gradually start to decay.

KIT is very interested in the history of landscapes and public places, and deliberately placed brightly coloured digital artwork in the 'romantic' or 'classical' landscape of the sculpture park. Video game landscapes are obviously artificial, but so are the sculpture park grounds because they were designed and made by landscape gardeners in the 18th century, and updated in the later centuries with such landscape fashions as a fake Greek temple and a zoo.

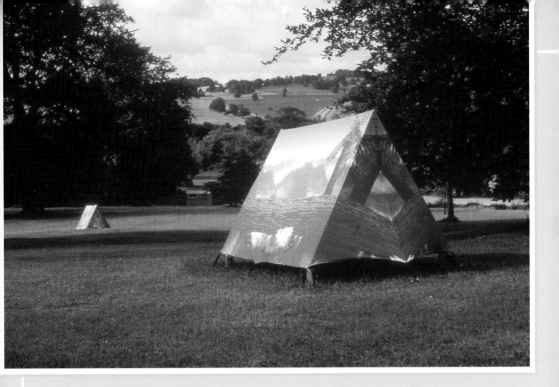

KIT also made an Internet computer game as part of this artwork, and an indoor **installation** called *Re*Action Hero* in the small gallery at the sculpture park. This installation was several large 'punchbags', again made of canvas with digitally printed images from computer games, and it refers to the violence of some games. With this artwork, KIT ask 'What is The Land the Time Forgot?' Is it the sculpture park itself with its bronze sculptures? Is it Jurassic Park? Is it the childhood game world of innocence or violence?

Working with others

KIT worked as a group on this project and started with researching the site and the ideas. They also organized other experts to make parts of the artwork. The digital printing onto the canvas was done by a commercial company.

Site-specific influences

Other artists who have worked with **site specific** artwork include Rachel Whiteread, whose concrete-filled *House* (1993) in London, reflected her interest in the themes of personal and public spaces, and a sense of history. She makes other artworks that appear in galleries or museums. Not many artists work with digital media in rural landscapes, but the *Makrolab* project placed a specially made large silver mobile living and working space in the Scottish Highlands in 2002.

Makrolab

The 'lab' was equipped with satellite telecommunications receivers and computers, and artists worked with 'streams of data', which were about anything from weather information to commercial communications, to make artworks. Rafael Lozano-Hemmer (see pages 28–31) also uses a combination of real urban landscapes and the 'virtual space' of the Internet.

Roaming the city landscape

Another artwork project by KIT also involved the landscape, but in a city setting. *KIT Homes* (1997) took place at a school in Widnes, UK, which was shortly to be demolished to make way for a private housing estate. KIT worked with children at the school to design 'ideal homes', and they also requested on the Internet that people send in their own plans. Selected floor plans by the children, and from the Internet, were then drawn onto the school playing fields, using a football pitch line marker that made chalk lines on the grass. Aerial photographs were taken of the site, and were displayed (along with the plans) on the Internet, and in an office on the school site, which mimicked the house sales offices of nearby construction companies. Because the school had been built with donations from the local community, which was mostly public housing, this artwork asked questions about public spaces and private places.

> [KIT Homes was made for] ... the local children of the community who would be able to remember the space when it was fields, but with their plans of perfection on them. KIT PUBLICITY MATERIAL

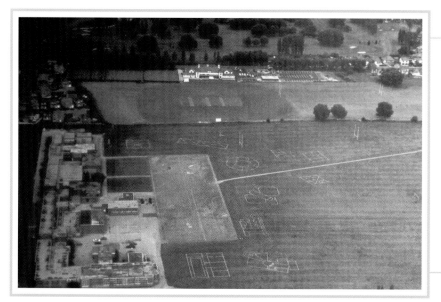

An aerial photograph of the KIT Homes *project, showing the chalk plans of 'ideal homes' marked on the grass.*

Because people could participate on the Internet as well as in the real place, KIT called the approach 'virtual geography'. Other KIT projects with the same approach include *Greylands*. These are projects where KIT travels to places including Mexico and Canada, choose a piece of wasteland (sometimes this land has been contaminated with industrial waste), and puts images of this land on the Internet. On the web site, people can 'buy' areas of land, and send in their plans for what they would do with their 'lot'.

KIT has also made artworks such as *Vacancy KIT* (1994) which involved encasing computers in concrete. Jen Southern (an artist who works with KIT, but who also does solo work) made an artwork called *Roam* (2001), which was a series of dresses from digitally printed fabric, advertised on a web site, shown in galleries and available from 'outlets'. Often, KIT makes artworks in places where you wouldn't expect to find art.

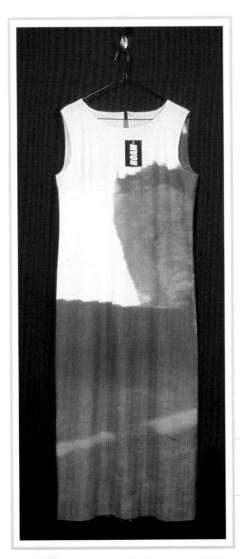
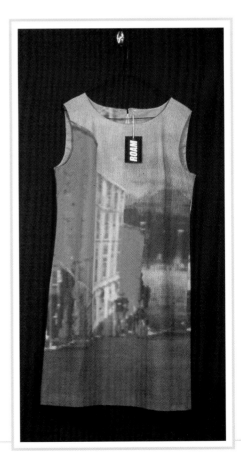

Dresses from the Roam *project (2001).*

RAFAEL LOZANO-HEMMER

Rafael Lozano-Hemmer is a Mexican-Canadian artist who makes **interactive** artworks for public places. He was born in Mexico City in 1967, and has a degree in Physical Chemistry. He has worked in radio and in the theatre, as well with new media such as **virtual reality** and the **Internet**. He now lives in Madrid, Spain.

Lozano-Hemmer is particularly interested in the relationships between people, places and artwork. He often makes large, spectacular outdoor light projections, where the audience can participate in a creative way. Some 'interactive' new media artworks only allow for very simple choices by the users, but Lozano-Hemmer's artwork is often 'participatory' because the audience can make their own ideas visible.

Body Movies, Relational Architecture No.6

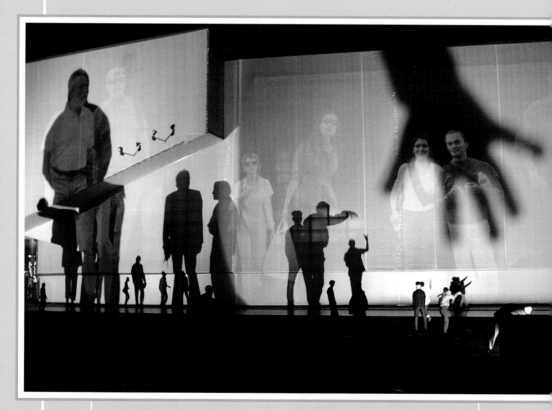

People interacting with Body Movies, Relational Architecture No.6 *(2001) in a public square in Rotterdam, the Netherlands.*

Body Movies is shown in public squares, and involves projecting images at night on to the large walls of buildings. One set of projectors shines some **digital** photo portraits of people (taken in Rotterdam, Madrid, Mexico and Montreal) onto the walls. A different set of bright white searchlights at ground level project the shadows of everyone crossing the square onto the same wall. These white lights have special lenses and are so bright that they wipe out the photographic projections, apart from where the dark shadows fall. If audience members make their shadows into the same shape as the portraits in the photographic projections, they can see the whole portraits, and are 'rewarded' by more portraits appearing.

Some people in the squares teamed up to cover the portraits, and others used the shadows to create their own visual jokes, dramas or communication. These interactions between people included friends and strangers, and ranged from the elaborate (with people bringing special props) to simple gestures. The artwork was in each square for about a month, and because shadows are familiar to people, the audience worked out for themselves what to do, rather than having to read instructions.

A dialogue

Digital media can make international communication possible, but can also be used for war and intimidation. Through his artwork, Lozano-Hemmer tries to make a 'dialogue' with the audience, and attempts to make them more aware of where they are, how their country might relate to another country, and how they use their own power or size. The artworks are called *Relational Architecture* because the artist says they are 'relationship-specific' for that particular audience and public place.

> *The key is to develop pieces that offer some degree of intimacy within an intimidating scale. Also to find participation metaphors [ways of taking part that are understandable] that are relatively familiar or self-explanatory.* RAFAEL LOZANO-HEMMER

Working method

Body Movies works because there is a video camera connected to some special computer **software** that can recognize when people's shadows are covering the portraits. This then triggers new digital portraits on the computer which are projected by **data projectors** that create large images of what appears on the computer screen.

Lozano-Hemmer carefully researches the location, plans how the audience might interact with the artwork, and then often works with technical experts to make the interface equipment. Large artworks can involve collaboration with many other people in a team, like a theatrical project, with a producer to help organize events. Lozano-Hemmer prefers to work with free software, rather than the expensive software sold by commercial companies.

Lozano-Hemmer has worked with theatre and performance groups in the past, and *Body Movies* has a direct reference to a 1675 **engraving** called *The Shadow Dance* where actors with fantasy props perform as shadows. Several kinds of performance allow for audience participation, including popular forms such as British pantomime, and the art 'Happenings' of Allan Kaprow (b. 1927) and others in the 1950s and 1960s. Large 'light shows' have a history that includes pop music concerts and political rallies.

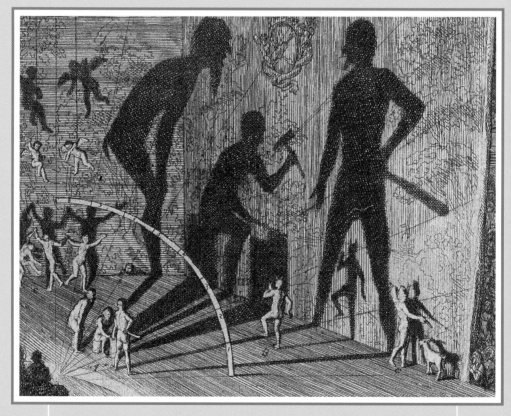

The Shadow Dance *by Samuel van Hoogstraten from a Dutch book called* The School of Drama, *1675. This shows a very old form of theatrical entertainment.*

Searchlights on the Internet

Lozano-Hemmer has made other artworks in his *Relational Architecture* series. No. 4 was called *Vectorial Elevation*, and involved eighteen very bright searchlights arranged around a huge public square in Mexico City. The movements of the searchlights could be controlled by the public, using an instruction page on the Internet. Several **webcams** around the square recorded each person's light show, and automatically saved the images on the Internet site, so that everyone could see a record of what they had made, and could type in a comment. There were also computer kiosks in the square, showing the same web pages, so that the audience was both local and international (from 89 different countries). The artwork was made by many people and over 700,000 people visited the Internet site. Public squares and buildings often have strong political or cultural meaning, and Lozano-Hemmer has made other artworks that 'make visible' the power and history of certain buildings.

Vectorial Elevation was a very big event to organize. A rock music tour company installed the lights, the control room had twenty computers and ten programmers made special software to connect the Internet instructions to the searchlight-moving mechanisms.

A child watching the light show Vectorial Elevations, Relational Architecture No. 4 *in Zócalo Square, Mexico City.*

Influences

Lozano-Hemmer's 'favourite projection artist' is Krzysztof Wodiczko (b. 1943), who projected site-specific political **photomontage** images onto the outside of public buildings in the 1980s and 1990s. This included putting a swastika on the South African Embassy building in London, to protest against **apartheid**. Other digital artists making **public art** outdoors include Susan Collins (b. 1964), and Christian Möller (b. 1959).

MARK NAPIER

Mark Napier was born in 1961. He lives in New York, USA, and was a painter until 1995 when he became interested in the **Internet**. His artworks have been chosen for exhibition by large art museums in the USA, including San Francisco Museum of Modern Art.

Internet Art

'Internet Art' or 'Net Art' is a relatively new kind of art, and people disagree on how exactly to describe it. It often does things that you can only do on the Internet: linking to other sites; changing over time; **interactivity** with Net users; making international connections; and using other people's data. Most of Napier's artworks exist only on the Internet, and could not really exist anywhere else. This makes his artworks very different from just 'showing art on the Internet'. The audience can return to his web sites to find that they never look the same way twice. Napier's art works with data, and is often playful.

I like data the most when it makes no sense. MARK NAPIER

Shredder

Shredder (1998) is a piece of Napier's **software** on the Internet, which takes any web site that the user suggests, and shreds the images, text and code of that site. It puts the shreds back together in an abstract arrangement, and shows this result to the user. The results can be colourful, chaotic, unexpected, and revealing of the hidden structure of web sites. Sometimes strange text can be seen, such as '<p>'. This is a computer code called **HTML**, that is used to write most web pages, but is usually invisible to the viewer. Shredder turns computer data into chaotic **montage**, and plays with a common fear that computers might somehow 'take over' or go wrong. Napier's work looks a like a computer virus might have wreaked havoc, or somebody has made a mistake in their web site. By doing this he also makes fun of technology itself. Napier is interested in the way, 'Text becomes graphics. Information becomes art.'

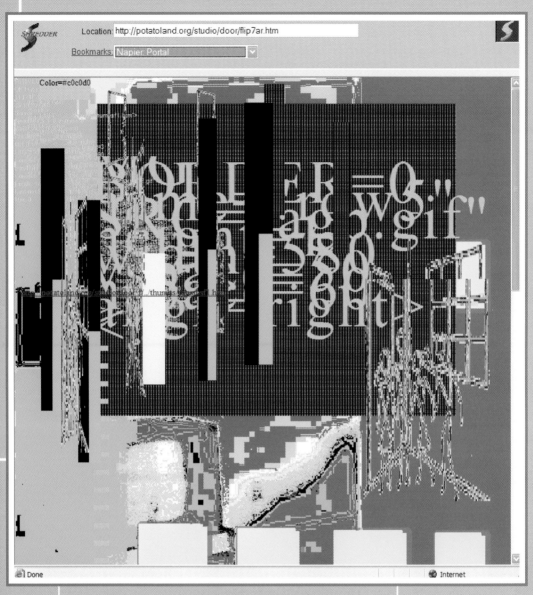

This screenshot from Shredder, *shows a shredded version of one of Napier's own web sites.*

Working method

Napier has worked as a commercial **computer programmer**, and for his Internet Art, including *Shredder*, he does his own programming using software including Java® and JavaScript®. He also writes special software 'scripts' to manipulate the basic data on the Web. The 'material' that he works with is computer code. Making Internet Art does not demand a particularly fast computer, because the files are quite small. Napier works as an individual rather than in a big team.

Spuds, flags and windows

One of Napier's earlier web artworks, *Spud* (1997), is a lighthearted look at the conventions of web **browsers**. Starting from an image of the humble potato, users find that when they click on the spud, the browser window behaves strangely – slicing and splitting the 'window' until the interesting textures of the potato are revealed, abstract shapes are created, and the **pixels** that make up **digital** images become visible. Commercial web browsers present only one dominant 'window' onto the data of the Internet, but Napier shows many other possible ways of looking at the code that is the World Wide Web.

This screen shows many small windows created by user interaction with Spud.

Napier's artworks such as *Pulse* and *p-soup* use different kinds of software to create smoother, more fluid graphics, which respond and change fleetingly when the users move their pointers over screen, rather like playing a musical instrument.

net.flag (2002) is a Napier artwork that is now in the collection of the Guggenheim Museum, New York. On the web site, users can make their own flags for the Internet from parts of other countries' flags, and save them on the web site. Some interesting graphics have been created, and also some interesting debate about nationalism, and whether the Internet (which is not a physical place) should have a flag.

Napier's artworks use various different kinds of interactivity, but all use the changeable and data-driven nature of the Internet.

Starting points in Internet Art

The Internet is obviously a new arena for artists, but there are some similarities with other, older, ways of making art. **Conceptual artists**, and the Fluxus group (1960–1970s), for example, sometimes used paper 'data' such as lists, forms and figures as a starting point for artwork. They also used 'mail art', where artists posted small artworks on paper to each other, and could interact by changing or adding to them.

The artist who probably invented the term 'net.art' was Vuk Cosic (b. 1966), a Slovenian artist whose Net Art often involved green ascii text (ascii is another kind of basic computer code). Alexei Shulgin (b. 1963), from Moscow has been making Net Art since the 1990s.

Lisa Jevbratt (b. 1967) makes art from data on the Internet. In her artwork *1:1*, abstract patterns of coloured pixels act like a like an out-of-control version of an Internet **search engine**. While commercial software designers aim to turn complex data into clear visual images, artists don't necessarily want to make things clear.

The different types of Internet Art are not established yet. Many artists are still experimenting, and many galleries and museums are also now experimenting with how to 'show' these works.

JANE PROPHET

Jane Prophet is an artist who is interested in the relationship between nature and technology, and between science and art. She trained in fine art, electronic graphics and arts education, and has made '**artificial life**' worlds, a **CD-ROM**, and **installations**. She was born in 1964 and lives in London, UK. Her work has been exhibited in Australia and North America. Her influences depend on the context of each project, and range from landscape gardening to scientific research.

TechnoSphere

A screen image from TechnoSphere, *showing creatures in the landscape.*

TechnoSphere (1995) is a screen-based computer **simulation** of a fantasy 'world', with computer graphics of trees, grassland and mountains. The users of the simulation can create their own computer 'creatures' by clicking and choosing a selection from body parts that are the pictured on the screen.

They can then let their animated creatures loose to live in the 'world'. The computer program sets a series of rules for the creatures. The creatures can also breed, and their characteristics will be passed on to their offspring. These creations can live up to three months, and users can check back to the web site to see how well their creature is surviving. Prophet is aiming to involve the audience through participation, and to make them question the differences between real and simulated life or landscapes.

A photograph of TechnoSphere (1995) installation for two users, at the National Museum of Photography, Film and Television, in Bradford UK.

Working method

There have been different versions of *TechnoSphere* on the Internet – for users to participate in – and there is also an installation in a museum in Bradford, UK. Prophet designed the idea and the creatures, and worked with a team of **computer programmers** to make the **software**.

Influences

Prophet is influenced by recent 'art science' debates that bring artists together with scientists who study the natural world. Simon Robertshaw, for example, made *The Nature of History* (1995), an installation in the Natural History Museum, London, which included a big projection of microscopic wriggling worms, and another projection tracking the movement of the audience across a grid on the floor.

KATE RICH

Kate Rich was born in Australia in 1968. She has worked on audio **webcasting** (like radio on the **Internet**), video, and cable TV projects. Like photography and video, sound recording and editing techniques have involved **digital** media for some time, so Rich uses both analogue and digital sound. Digital sound files can be used in **multimedia**, performance, or on the Internet.

Rich works with other young artists as well as working alone. Her projects often use the features of digital media that are mobile, live, temporary and sociable. Rich has worked in Australia, the USA and the UK.

Live-stock

This screenshot is taken from the Live-stock *(2000) archive web site.*

Live-stock (2000) project presented 72 hours of experimental audio artwork, including music, short stories, interviews, DJs, heartbeats broadcast through a stethoscope, and sounds produced by a circular saw connected to electronics. The event happened at an arts centre called The Arc in Stockton-on-Tees, UK, in front of a live audience. The audio was broadcast on local FM radio (which reached a radius of about 70 miles) and via webcasting on the Internet (which reached anywhere with Internet access, internationally). Local community groups, and international sound artists such as *Project Dark* participated, with Rich acting as Artistic and Technical Director of a team of people. An example of one of the 60 audio works broadcast was Geoff Broadway's *Salt Passages*, which was made up of parts of interviews with people from Middlesborough, UK, mixed with electronic sounds and music.

An event

This kind of digital audio event has more in common with performance than with objects in galleries. Audio art is not usually straightforward music, but might involve noises or an **installation** in a particular place. Some audio artworks were performed live in the Arc, and others were sent from other places as digital sound files or analogue (not digital) tapes. The event involved dancing, socializing, and people staying up all night. Audio artists are often young people who share their technical sound mixing skills with others who have Internet webcasting skills.

> *I wasn't classically trained in art, electronic media, computers or miniature helicopter operation – so I've had to pick most of it up along the way. I get a lot of my information from the Internet. What's interesting is how to educate yourself in things that might be outside normal fields of study.* KATE RICH

Sound files

After *Live-stock*, the web site was archived (saved), along with all of the sound files, and some pictures of the live event, so that people could go back and listen – unlike ordinary radio. The equipment needed for streaming audio on the Internet is relatively low-tech, but can sometimes be a bit slow and unreliable!

Individual sound artworks on the Internet tend to be quite short, because people might have to pay to be **online**. The sound quality of live Internet streaming can also be quite low, because the Internet can only cope with so much data at a time, so artists need to adapt their sounds to that. It is also possible to webcast images, but again they can be rather small, and of poor technical quality.

Improvising from near and far

The *Flat of Culture* (2001) project also involved audio webcasting, but from a more unusual domestic setting – a council flat in a tower block in Newcastle, UK. This was 49 hours of continuous 'Net broadcasting', and Rich worked collectively with Sneha Solanki in a partnership called *Hostexe*. This project included visual images being streamed from Slovenia and Croatia, and also included an Internet chatline on which people sent typed messages from thousands of miles away, and from neighbouring flats. The audio artworks included one inspired by Morse Code – an early kind of telecommunication that was developed in the 19th century.

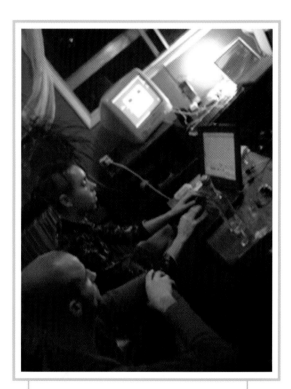

Kate Rich (top) during the Flat of Culture *project.*

Equipment

A basic level webcasting set of equipment for something like the *Flat of Culture* project was: three iMac® computers, a basic sound recorder and mixer, lots of cables, an ISDN telephone (faster than a regular telephone landline), free Realsystem Producer® **software**, and help from a webcasting **server**. Rich's projects often 'share the knowledge' by including on the web page some details of how it was done.

Rich's projects are often improvised around what kinds of technology are already available, such as *Broadbandit Highway* (2001) which used the television network channel of the Great Eastern Hotel in London. *Hostexe* improvised a live soundtrack to go with images taken from traffic surveillance **webcams** on international web sites. This was broadcast into every television in the hotel during the opening night.

Rich has also worked as a radio engineer/videographer with another digital media art group; the Bureau of Inverse Technology (BIT). BIT have worked with remote control, webcams and **robotics**. The group make projects such as a remote control toy dog that wandered around buildings 'sniffing' for radiation and a remote control toy plane with a video camera, that flew over Silicon Valley (a place in California, USA, where the high-tech companies have very strict 'no camera' rules).

Influences and other artists

Rich has collaborated on many other projects combining local radio with Internet radio. For example, she has worked with *Radioqualia* (who contributed to *Live-stock*), who broadcasts experimental audio art, and has included soundworks that were based on recordings of radiation from outer space. Internet radio can be done by small groups of people, and has been influenced by the 'pirate radio' of the 1970s, which provided an alternative to the big radio broadcasters.

Popular music, especially Techno, has used digital sound techniques for some time, as this makes it easier to make, copy, repeat, distort and **sample** sounds.

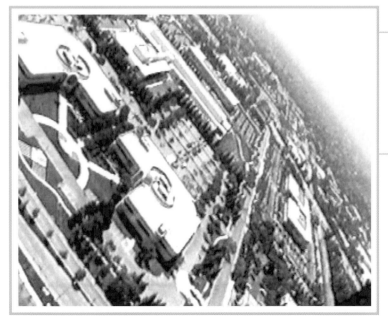

This image of Silicon Valley was recorded by the BIT model plane.

PAUL SERMON

Paul Sermon makes '**telematic**' artworks using telecommunication lines to transmit live video images between different places. Audience participation, and **interaction** between people is very important in his artwork. Sermon was born in the UK in 1966. He obtained a Fine Art degree at the University of Wales, and has lived and worked in Austria and Germany.

Telematic Vision

You are having an out-of-body-experience

Telematic Vision *(1993). The person in the centre is in a different room, but the three people appear to be together on the video screen image.*

Telematic Vision (1993) artwork involves two rooms (which could be in different cities or countries) with identical sofas and TV screens in them. The TVs, video cameras and computer controllers are connected by telephone lines. If a person sits on the sofa in one room, then they can see on the TV screens a video image of themselves, **montaged** together with a live image of whoever is sitting on the sofa in the other room. People soon work out what is happening, and find ways to interact visually, such as appearing to sit on each others' knees, appearing to push each other off the sofa, showing each other their shopping, and so on.

Blue screen

Telematic vision works with 'blue screen' techniques, like those used in television when the actors are filmed in a blue studio, so that different backgrounds can appear behind them. Here, the sofa and cushions are blue, so images from the other room can appear in those areas. Sometimes, words and pictures by the artist also appear in the videos.

> *The difference between the remote telepresent body and actual physical body disappears; leaving only one body that exists in and between both locations.* PAUL SERMON

With *Telematic Vision*, Sermon is carefully designing the 'interactive shell', and then letting the audience have a lot of creative input of their own. His use of telecommunications refers to everyday **digital** media: mobile phones are everywhere, there is a camera on Mars that sends back images and bomb disposal experts can send robots with cameras and tools to be telepresent in places that are too dangerous to be there in the flesh. Some people are worried that this might mean that people have less face to face interaction. *Telematic Vision* encourages both telematic interaction, and interaction between those watching and participating in each gallery space.

This artwork has appeared in the Play Zone of the Millennium Dome in London, in a new media arts centre in Japan, in science museums and in several art galleries. A version of it also appeared as part of a larger **installation** by Sermon, called *There's No Simulation Like Home* (1999). This was set up like the rooms of a house, with a telematic table, and a telematic bed, which worked in a similar way to the sofa installation.

Technical experience

Sermon has gained a good working knowledge of telematic technology through experience, and through working at specialist digital media art centres, such as ZKM in Germany. Sometimes he works with technical experts, but often his work can be done relatively simply via ISDN telephone lines that are like domestic telephone lines, but can transfer information faster. The most important thing for these telematic artworks is thinking about how it can be made easy and comfortable for people to interact. Sermon has spent a lot of time watching how people use his artworks so that he can apply that knowledge to his next project.

There's No Simulation Like Home *(1999). This is a photograph of one room, showing the blue sofa and background, and people watching a video screen.*

Reality, time and connections

Sermon has been working with digital media for quite some time. In 1991 he made an interactive **multimedia** piece which worked on a single cheap Commodore Amiga® computer. Each different telematic installation encourages different kinds of interactions.

In 1997, *A Body of Water* was a telematic installation in Germany that linked a shower room in a coal mine with a room in a museum. The video images of visitors in each place were mixed together with historical film footage of miners showering, and projected onto a 'screen' made of running water. This made an interesting ghostly effect, and contrasted 'live' video pictures with images from the past.

Whether telematic images are really 'live' or 'real' is an interesting question, and Sermon played with this idea in his artwork *Heaven 194.94.211.200* which was a web site that promised to '…bring live images of heaven directly to your computer screen.' The publicity material asks: 'Can you believe in a machine that connects you to the globe any more than a machine that connects you to heaven?'

Influences

Many artists using telematics have been influenced by the early work of Kit Galloway and Sherrie Rabinowitz, such as the 1977 *Satellite Arts Project*, which used live satellite television broadcast so that dancers and performers in two different places could appear to be dancing together in the same space. Their *Hole-in-Space* project (1980) simply linked two public places in New York and Los Angeles with life-size television pictures and sound. No instructions were given, but the public used it for family reunions, for singing to each other and for 'meeting' and making new friends!

Images can be transmitted telematically via simple videophones, or via satellite broadcast, but one of the most accessible ways is via the Internet. *The Telegarden* (1995–99) by Ken Goldberg and others, was a web site where users could direct a real robot arm to tend a small indoor garden that can be seen through a live **webcam**. Lynn Hershmann Leeson's *Tillie, the Telerobotic Doll* (1995) is another web site where a rather sinister-looking doll has had her eyes replaced by webcams, and the user can see what the doll sees. This artwork asks questions about surveillance, and who is watching who.

BILL VIOLA

Bill Viola is an artist who has worked with **video art** since it was first developed, and who has pioneered the use of some new **digital** video techniques. He has slowly built up an international reputation for video **installations**, featuring large images and strong sound. He was born in 1951 and lives in California, USA. In 1998 he was the 'Scholar in Residence' studying historical paintings at the Getty Center in Los Angeles.

His striking images deal with the big issues of life, death and spirituality. There is often a strong theme of water in his work, which is related to his life experience of almost drowning when he was a child. Viola wants to give people time to think, so his videos are slow and thoughtful.

Going Forth by Day

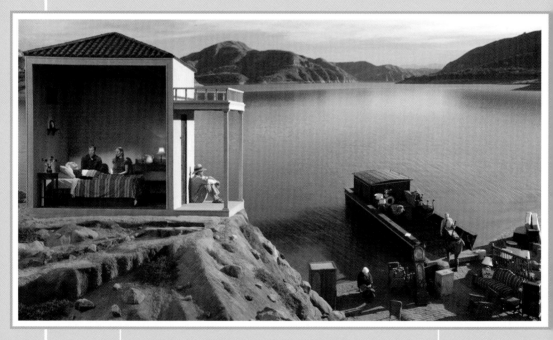

This is a still image from the video 'The Voyage', panel 4 of Going Forth By Day *(2002).*

In one big gallery, there are five large projected digital image 'panels'. This is *Going Forth by Day* (2002). Each panel shows a different scene: a body moving underwater, a line of people walking through a forest, a street where a building gushes water and washes people away, a lake where a boat waits to take an old man to the other side (see '*The Voyage*' picture, left) and a pool where a figure rises out of the water and goes up into the sky.

They are all shot in high definition digital video, which means that the images are so crisp and detailed that they look slightly unreal. The very careful lighting, the strange images and the fact that the videos are very slowed-down adds to the dream-like effect. The videos take 35 minutes to run and Viola wants the whole installation to reflect 'the cyclical nature of life' (a circular spiritual journey) rather than a linear narrative (a simple story with a beginning, middle and end).

Going Forth by Day *is intended to be like a walk-in theatre ... as if the five major scenes of a movie were playing simultaneously. The audience itself unfolds the narrative as they walk through the space.* BILL VIOLA

Influences

The artist relates his work to various religious paintings that tell a story, such as Giotto's **frescos** in the Scrovegni Chapel in Italy, which are painted on every wall of the chapel and make a narrative 'installation'. Viola has a particular interest in medieval and **Renaissance** art history. '*The Voyage*' has an unusual **perspective**, and a cutaway house so that we can see the story inside. This was done using digital video **montage**, but it also looks like some early Renaissance or Indian narrative illustrations, which were made before conventional perspective rules were fixed.

The visual symbols used by Viola are taken from Biblical stories such as The Flood, but he also uses symbols from Greek mythology, such as crossing the River Styx into the after life. The title is from an ancient Egyptian book where the soul is described as leaving the darkness of the body and going forth in the light of day.

Techniques

Going Forth by Day was a particularly complicated project, and took over a year and a half to make. Sponsorship had to be found to fund the project as high definition video is expensive to use and edit, and a large team of people, such as a film crew and stunt actors, had to be employed. Viola has gained a lot of technical knowledge through his experience, but he still works as a 'director' on the larger projects, and is advised by experts.

Some of the videos were shot in a studio, with complicated lighting to make it look as though dawn was breaking. After shooting the videos, lots of editing and montaging of the images took place in a commercial postproduction (editing) studio.

This photograph was taken during the making of 'The Path' (panel 2 from Going Forth by Day*). It shows Bill Viola measuring in pixels the position of overlap of video shots.*

Other artworks

Viola's theme of water emerges again in *The Crossing* (1996). Two **video projections** were installed: in one, the figure of a man stands in a darkened room and water floods down from above until he seems to disappear. In the other video, he appears to be slowly engulfed by flames. Each takes only a few minutes, but the strong sounds and images of water and fire are dramatic.

A still image from the video installation The Crossing.

Video is itself projected light and lighting is very important in video art. Time is often used creatively in this artist's work. Viola's *The Quintet of the Astonished* (2000) shows five actors displaying various emotions. The video is played on a flat panel high-resolution digital display (like a flat high-quality TV screen). When put on the wall of a gallery, these displays look rather like a painting in a frame, but the viewer gradually realizes that the images are moving very slowly. The audience is asked to question the differences between video and painting.

Video Art

Sometimes video is recorded, edited or displayed digitally, and sometimes it is analogue (not digital). Like photographers, video artists sometimes use both digital and non-digital methods. Digital video images can be manipulated and edited on a computer, and are easier to copy without loss of quality.

The early video art of the 1960s has influenced the development of many kinds of new digital media. Video then was used for community art projects, for narrative and for installations: Nam June Paik (b. 1932) was one of the first artists to take video art beyond the single screen and into installation. In his artwork *Digital Merce* (1988) he stacked up video monitors into the shape of a dancing figure and played video on the screens.

TIMELINE

1801	French engineer Joseph Marie Jacquard designs a weaving loom that uses punchcards to control the patterns on the fabric
1834	English inventor/mathematician Charles Babbage invents the first computer
1945	World War II ends
1950	Jenny Holzer is born
1951	Bill Viola is born
1952	Queen Elizabeth II is crowned in London
1959	Roshini Kempadoo is born
1960	Graham Harwood is born
1961	Mark Napier is born
1964	Jane Prophet is born Douglas Engelbart (inventor of the computer mouse) demonstrates the use of 'windows' and graphics on a computer screen
1965	Nam June Paik uses an analogue video camera for the first time
1966	Natalie Bookchin is born Paul Sermon is born
1966	First episode of Star Trek is shown on television
1967	Rafael Lozano-Hemmer is born Charles A. Csuri creates a simple computer graphics **animation** called 'Hummingbird'
1968	Kate Rich is born Cybernetic Serendipity exhibition at the Institute of Contemporary Art in London features 'computer art', including a robot that responds to the presence of people, and drawings made with a simple computer plotter
1969	US atronauts Armstrong and Aldrin are the first humans to walk on the moon
1970s	Announcement of the 'personal computer' for domestic use
1979	The first Ars Electronica Festival (digital arts festival) in Austria
1980	CDs first appear in shops
1982	Pac-Man computer game becomes popular

1983 Apple's 'Lisa' microcomputer is launched – the first to use graphics as a user interface

1984–89 *Egg Grows*, a video **installation**, is created by Nam June Paik

1986 Sony's first digital video recorder, the DVR-1000, is released (but digital video cameras are not affordable to ordinary consumers until the late 1990s)

1989 Fuji/Toshiba's first digital still camera is released (but digital still cameras are not affordable to ordinary consumers until around 1994)

1990 Photoshop® 1.0 is released (**software** for manipulating digital images on a desktop computer)

1991–95 War rages between the different parts of the former Yugoslavia

1993 Jenny Holzer creates *World II*
Paul Sermon creates *Telematic Vision*

1994 The first fully free elections held in post-apartheid South Africa

1995 Ars Electronica includes a "World Wide Web" category in their art prizes for the first time
Jane Prophet creates *TechnoSphere*

1998 Mark Napier creates *Shredder*
KIT creates *Joyriding in the Time that Time Forgot*

1999 Net_condition exhibition. A survey of Internet Art, includes curators from Germany, Japan and the USA.

2000 Roshini Kempadoo creates *Future Belonging*
Graham Harwood creates *Uncomfortable Proximity* (Tate Britain's first web art commission)
Kate Rich creates *Live-stock*
Tate Modern opens in London

2001 Rafael Lozano Hemmer creates *Body Movies*

2002 Natalie Bookchin creates *Metapet*
Bill Viola creates *Going Forth by Day*

GLOSSARY

activist someone who takes action about an issue

animated moving, or something that is made to move

apartheid separating people by race or colour

artificial life computer programs that mimic or simulate the ways in which living things behave or evolve

browser software that enables you to browse through the data on the Internet, for example Netscape Navigator®

CD-ROM stands for Compact Disc Read Only Memory. This is a disc on which images, text and data can be stored, and then played back on a desktop computer. CD-ROMs can be interactive.

commissioned where a gallery gives an artist money to make a new artwork, rather than showing an artwork that is already made

Community Art any art-making project involving non-artist groups such as youth clubs, at its height in the 1970s–80s in the UK

composition how visual images are arranged within a frame

computer programmer person who writes the code that make computers work

Conceptual Art late 20th century art movement, that was more concerned with ideas, events and processes than with the creation of traditional art objects

data projector machine, like a slide projector, which projects images from computers or videos

digital not analogue, but made up of a series of digits (numbers – zeros and ones in the case of computers)

digital print print from a digital image file. Artworks on paper are usually printed by an inkjet printer.

engraving early form of printing where an image is scratched onto a metal plate, which can then be used to print many copies on to paper

fresco artistic technique of painting directly on to damp plaster on the walls of buildings

genetic code 'code' made of genes and DNA that we inherit from our parents which controls the characteristics of our bodies

HTML HyperText Markup Language, the computer code used to make web sites

ink jet printer printer which squirts images on to paper or other materials using tiny jets of ink

installation artwork involving putting any kind of media into a specific three-dimensional space, such as a public building

interactive 'acting upon each other'. In digital media art, this tends to mean interaction between a computer-controlled artwork and the user.

Internet worldwide system of computers linked by telecommunications

montage French word meaning 'putting together'

multimedia several media together, such as sound, images and animation

online connected to the Internet

perspective art of drawing three-dimensional objects on to a two dimensional plane, such as a piece of paper

photomontage putting together of different photographic images

pixels tiny square blocks of colour that make up digital images

public art art displayed in public – in parks, the outside of buildings and other freely accessible places

Renaissance a revival of art and technology in the 14th-16th centuries

robotics the making of automated machines that carry out physical tasks

sampling copying parts of digital sound or image files and using these as part of another sound or image artwork

scanner piece of equipment like a photocopier that saves an image as a computer file

search engine on the Internet, a search engine is a site such as Google® or Jeeves® where the user can type in words to find other sites on the Web

server computer connected to the Internet, where web sites are stored

simulation computer software that imitates the rules and relationships of a real place or situation, over a period of time

site specific artworks made for the context of a certain place, that would not have the same meaning in another place

software programs used in computers

streaming on the Internet, images (or sound) can be 'streamed' live so that people can see them happening on the web site

Surrealism early 20th Century art movement that grew out of Dadaism. Both were interested in liberating the unconscious mind.

Tamagotchi Japanese name for the small computer toys popular in the late 1990s featuring 'pets' that the user had to press buttons to 'feed' and keep alive

telematic using telecommunication lines or satellite communication to transmit information between different places

video art art using analogue or digital video which started in the 1960s

video projection image projected from a video by using a data projector

virtual reality or 'VR' uses computer graphics to simulate a 3D space that the users can appear to move through, often using a headset with 3D visual display, and headphones

webcam small camera connected to the Internet, so that users can see live images of a place

webcasting live streaming of images and/or sound on the Internet

KEY WORKS

NATALIE BOOKCHIN
2002 *Metapet*
1999 *The Intruder*

GRAHAM HARWOOD
2000 *Uncomfortable Proximity*
1999 *Linker*
1995 *Rehearsal of Memory*

JENNY HOLZER
1993 *World II*
1993 *World I*
1977 *Truisms*

ROSHINI KEMPADOO
2000 *Future Belonging*
2000 *Virtual Exiles*

KIT
1998 *Joyriding in the Land that Time Forgot*
1998 *Re*Action Hero*
1997 *KIT Homes*

RAFAEL LOZANO-HEMMER
2001 *Body Movies, Relational Architecture No.6*
1999 *Vectorial Elevation, Relational Architecture No.4*

MARK NAPIER
2002 *net.flag*
1998 *Shredder*
1997 *Spud*

JANE PROPHET
2000 *The Landscape Room*
1995– *TechnoSphere*

KATE RICH
2001 *Flat of Culture*
2001 *Broadbandit Highway*
2000 *Live-stock*

PAUL SERMON
1999 *There's No Simulation Like Home*
1997 *A Body of Water*
1997 *Heaven 194.94.211.200*

BILL VIOLA
2002 *Going Forth By Day*
1996 *The Crossing*

WHERE TO SEE WORKS

Here are the galleries and public places where the works of art mentioned in this book can be seen. Ring or check the web sites to find out what is showing before you go:

The FACT Centre (Foundation for Art and Creative Technology) – A new digital media arts centre opening in 2003 in Liverpool. www.fact.co.uk/

National Museum of Photography, Film & Television, Bradford – Includes artworks by Paul Sermon, Jane Prophet and others. www.nmsi.ac.uk/nmpft/

The Science Museum, London – The new Wellcome Wing includes artworks by Gary Hill and Christian Moller. www.sciencemuseum.org.uk/

The following web sites show work by the digital artists in this book and by others:

www.calarts.edu/~bookchin/ – Natalie Bookchin
www.metapet.net/ – Natalie Bookchin
www.tate.org.uk/netart/mongrel/ – Graham Harwood
www.artmuseum.net/w2vr/timeline/Holzer.html – Jenny Holzer
www.futurebelonging.c3.hu/ – Roshini Kempadoo
www.gas.u-net.com/ – KIT
www.telefonica.es/fat/artistas/rlh/eprlh.html – Raphael Lozano-Hemmer
www.cairn.demon.co.uk/ – Jane Prophet
www.technosphere.org.uk/ – Jane Prophet
www.hostexe.org/airshow/ – Kate Rich
www.live-stock.org/ – Kate Rich
www.hgb-leipzig.de/~sermon/ – Paul Sermon
www.billviola.com/ – Bill Viola
http://rhizome.org – Rhizome
www.mediahistory.umn.edu/time/ – Media History Timeline
www.isea-web.org/ – ISEA (International Symposium of Electronic Arts).
www.sfmoma.org/espace/ – San Francisco Museum of Modern Art
www.iniva.org/ – Iniva, London
www.walkerart.org/gallery9/ – Walker Art Center, Minneapolis.
www.mediascot.org/ – New Media Scotland, Edinburgh.
www.ntticc.or.jp/ – The ICC digital media centre in Tokyo, Japan.
www.whitney.org/artport/ – Whitney Museum of American Art, New York.

FURTHER READING

Art and Design, no.39: Art and Technology. (Art and Design, 1995)
Multimedia from Wagner to Virtual Reality, http://www.artmuseum.net.
Designing the Future: The Computer Transformation of Reality, Robin Baker (Thames and Hudson, 1993)
New Media in Late 20th-Century Art, Michael Rush (Thames and Hudson, 1999)

INDEX